POETRY:

The Epitome of Life and Hope

DOMINIQUE WRIZILE

iUniverse, Inc.
Bloomington

Poetry: The Epitome of Life and Hope

iUniverse books may be ordered through booksellers or by contacting:

iUniverse
1663 Liberty Drive
Bloomington, IN 47403
www.iuniverse.com
1-800-Authors (1-800-288-4677)

Because of the dynamic nature of the Internet, any web addresses or links contained in this book may have changed since publication and may no longer be valid. The views expressed in this work are solely those of the author and do not necessarily reflect the views of the publisher, and the publisher hereby disclaims any responsibility for them.

Any people depicted in stock imagery provided by Thinkstock are models, and such images are being used for illustrative purposes only.

Certain stock imagery © Thinkstock.

ISBN: 978-1-4759-6482-0 (sc)
ISBN: 978-1-4759-6483-7 (e)

Library of Congress Control Number: 2012922728

Printed in the United States of America
iUniverse rev. date: 12/19/2012

GRATEFUL

For all I am going through,
poor as a church mouse, but
proud of the womb that bore me
and the breasts that nursed me,
I am grateful and happy to be alive.

My heart is deeply lonely, but
I am not bitter or depressed.
In crisis I see opportunities;
my spirit is high and I am focused.

With ups and downs in this life,
in this world of the strongest and the smartest
where survival is for the fittest and the cleverest,
I am not worried because I know I will make it.

It's not easy to be the greatest, that much I know
and the narrow road I'm taking is full of thorns and rocks,
but I am full of hope and my soul is invulnerable.
I live in my head:
my mind is my government.

OUR GREATEST ENEMY

Our greatest enemy is not our powerlessness;
our greatest enemy is time.
It's not the past or the future that defines us, but the present.
It's not what we say or do that makes us unhappy, but what we do not.
Your tendency to quit and run away from problems
does not solve them or make the world a better place,
for it's not problems that destroy us, but fear.
When you confront problems and understand that they
are not there to break you, but to make you,
you unknowingly make the world a better place and inspire the
person next to you.

I TOO

Out here, I am invisible.
They underestimate me and think
I am not able to touch the sky,
but I swallow my pride: keep quiet and laugh
for I know it is a matter of time: only the sky will be my limit
and no one will dare underestimate me ever again
for they will see how capable I am and the territories I have
conquered.
Ashamed, their heads will drop when they realize
I, too, I am good enough.

FOOLS

Do not argue with fools.
For most fools are dull,
that's what makes them fools.

You become twice a fool
for arguing with a fool
yet knowing he is a fool.

MY MIND IS MY GOVERNMENT

My emotions do not control me;
I control my emotions.
I decide what should bother me
and what should not bother me.
I am my own devil:
the master of my destiny.
My mind is my government.

LIFE

Life is without logic.
It isn't good or bad;
it's sensual.
Everything in it is
based on perception.
You can be a great man or a great criminal:
a champion of something or
a loser too brainwashed to smell the scent of its sensuality.

HAPPINESS

Lose yourself.
Be formless.
Think like a child.
Live to the utmost.
Eat, drink and make love to life
and you will find life more meaningful.

Forget being rational
and listen to your heart.
Think less and feel too much.
Who knows, the sun might rise tomorrow
and find you as happy as a pig in shit.

PEOPLE

People are just people,
but what they do
and what they do not
is what makes them good or bad.

IMAGINATIONS

Only through
their imaginations
can men fully begin
their journey to success.

This has been
and always shall be
the way of things.

LOVE

A bond of love and trust between soul mates.
It exists before sharing an intimate kiss,
it remains unknown and sufficient to itself
until the universe unites them.

SOUL MATES

Those who contain love,
remain in love.

DESIRE

When the desired comes,
 desire disappears.

HOPE

A human being without hope
is like a vessel without a compass.

FRENEMY

She has no borders,
she is mobile and famous.
Primitive you look, if you are not fond of her
because she makes people fly without wings.
She traps your mind
and makes you feel she is
your best friend and you
cannot do without her.
She thinks of nothing but to trap you,
she sits in her office and checks your record
aggressively and quietly.
She crawls, glides and tempts you.
You get trapped; she smiles and
says "
thank you."
She takes control.
You lose control.
You plant and she harvests.
You keep losing
and she keeps winning.
Now, she is in command.
You are a slave and she is a master;
you work harder and she works less.
Champagne and chicken she enjoys
while beer and chips are all you can afford.
In the net, you have been trapped.
So miserable you look,
sleepless nights you get;
dilemma is your friend.
Your problems are your problems.
She looks at you straight in the eyes,

then your back she stabs.
You do not answer your phone twice
so the officer in a suit takes the
case.
Be careful: she is killing you softly.

THE WISE COOKIE

Before the pope was an altar boy,
she was there.
She has been around for many a moon.
She is mobile and worldwide and
she is trusted by the majority.

She is the source of information.
She knows a lot and stores a lot, but she is tricky and wise.
She can twist A to B, then B to A in a second.

She gets more excited by seeing
imperfection instead of perfection.
She persuades your mind and makes you dance
according to her tunes, indirectly.

With only one word,
she can make you or break you.
To her, you are like a fresh fish;
she can bend you up and down then
decide whether to trash you or let you go.
So, edit yourself before you shake hands with her.

It is defined by two words
but written as one word.
The desire for it fills us.
Get up every day, go out
there and do what we can
to make it happen.

From coast to coast,
everybody is looking for that one thing.
Some find it and some end up
spending their entire life
looking for it, but they do not find it.

The wiser, the educator
and the educated
can teach you all the tricks
in the book, but they cannot
teach you how to find that one thing.

There is a short distance
from Z to A where that
one thing stands, but what
is in that short distance is
what makes some find it and
some not find it.

THE WISE

Through him, the words they learned to sing.
Step by step, the numbers he showed them how to count.
The principles of life, he showed them.

Their eyes, he opened and the light ahead of them they saw.
Their rights, he showed them and their mind became enlightened.
Their speeches, he edited.

From the bottom level to the highest level, his knowledge they
depended on,
From the king to the ordinary man, through him they all passed.
With their legs fit and strong, he gave them shoes to climb the
mountain.
The best professionals in the community, he produced.
They get paid in chicken and champagne,
but he is being paid in chips and beer.
Is that fair?

THE WORD

We all know the word.
Men and women all hate the word,
all races hate the word,
poor or rich, young or old –
none like the word.
Even when the pope was an altar boy, the word existed.
In today's global world, the word still exists.
So how long shall you carry that luggage on your shoulders?
How long shall those tears keep falling on your face?
Because the word is the word, and its part of you.
It lives with you, through you, in you.
You cannot hide from the word because it knows how to find you,
so put a smile on your face and stop hiding from the word, but
confront it
because the word is not there to break you, but to make you.

BONE THE UNCHEWABLE

O bone, the unchewable.
Angelic to my eyes.
You, my treasure
release me.

In the net, I am trapped.
I do not wish to escape
but I must
and pain fills my heart.
O bone, the unchewable, emancipate my soul.

On my knees I am
conquered by gravity.
Gravity, a strong force,
a force too strong
yet too sweet to let go.
O bone, the un-chewable, unchain me.

I want to keep swimming
but I cannot swim with these boots on.
I want to keep driving, but
I cannot drive with the break on.
O bone, the unchewable, rescue me

I have been so honest with you, gravity
but how honest have you been with me?
O bone, the un-chewable: to unchain my heart,
I am going to set it ablaze to save it from this plague.

WHAT CAN YOU WITHOUT IT

It is a source of unhappiness,
but its absence brings sadness.
The human mind, it corrupts.
Problems in the global village, it brings.

It betrays peace,
it betrays love,
it betrays honesty,
it earns false respect.

It takes lives,
it saves lives,
it shapes life.

What can you do without it?

BLUE LIKE JAZZ

Unmoved mover,
changer of the changeable,
the incorruptible,
creator of the corruptible,
omnipresent, purer than the pure.
Free thinkers know him,
Fundamentalists know him;
we all know him in different ways,
so why can't we balance our beliefs about him
so we can live together at peace?

THE INNOCENT SPIRIT

A dirty, innocent spirit at the two rivers,
too bad I was not able to swim in both
and be part of a happy, clean family.
On the edge I was
careful, I stood then considered
other possibilities as deeply as I could
to where and what extent my body could be cleansed,
then, I jumped into one as happy as a pig in shit
with no second thoughts
because I was trapped in the net and needed to escape
the decision I had made.

Mzee warned about the consequences;
I considered the consequence, but still,
my heart was content with the decision made.
With courage and determination, I crossed the Rubicon
yet I knew I was falling into okra soup.
A dirty, innocent spirit at the two long rivers
and I dived into the dirty one
and that gave me hope.

BLUE

It's blind.
It's kind.
It never pretends.
It's uncontrollable.
It's easily forgiving.
It's humble and trusting.
It's giving.
Lies destroy it.
Truth nourishes it.
It brings happiness.
It brings togetherness.
It brings contentment to the heart.

THE LOVE NOT LOVED

Two loves hunting for love.
Unfortunately, I was not able
to love them both equally at the same time
and I let them see the shape of my heart, as deep as I loved
and ignored my feeling for the one
as much as I could
simply because she was content and had it all figured out,
then, I embraced the other as simple as that
because she was on the edge,
and needed to be fixed and feel
the human touch.

The spectator kept on speculating,
but none knew the state of my mind.
Oh, I gave the one a goodbye kiss
in spite of she and I being on the same page –
two loves hunting for love – and I,
I embraced the love not loved
and that changed her life.

CONFESSION

Our brilliant life, perfect.
Where beauty and love met,
dirty secret I deeply kept
from your eyes and ears and heart.

Poor, darling, lovely prince,
with your promises and love,
I still can't disclose the riddle
though I know the truth will set me free.

With a heart harvesting pain,
memories seeping from my veins
I keep watching my lanes,
while my mind is in chaos.

Motivated by fear with respect,
blindly and suddenly
I joined the party.
The knot I tied foolishly,
false promises I made.

Life goes so fast.
My heart is about to blast.
How can I reveal this from my heart
so I can feel free at last?

My mind, guilty has conquered.
My heart, fear has defeated.
My secret, I keep quietly,
but my heart burns softly.

Deeply the secret I expose
and let the truth set me free.
It's not you, but wealth I love.
My love to you is fake.

I don't have much to say
for I have said all I can say,
but if you forgive me I will be at peace.
I wish you luck and all the best in life.

Tell her she is hot,
tell her she is the treasure you long to find,
tell her that her beauty nourishes your soul.
Who knows? Maybe she'll even let you put your junk in her trunk.

SIDNEY

In the hallway I saw you
with a face so beautiful,
beautiful, like moonlight,
eyes like a sunrise
mwenye shingo la upanga
so angelic you are.

I have high expectations of beauty.
And just so you know,
you are the pinnacle of my expectations:
a conclusion of the higher beauties,
and blessed is the womb that bore you
and the breast that nursed you,
because you are a shining star.

MY ANGEL

I was lonely,
had no hope for tomorrow,
was just not focused,
wasn't hoping for anything,
destructed by the power of insecurity,
living in the shadows,
and then, out of the blue,
an angel touched me.
I was frightened,
but now I am blessed

She gave me hope,
she shaped my life,
she pulled me up,
like only an angel can.

She is not judgemental;
she is very easygoing,
understanding and good-hearted.
It's unbelievable how caring she is.
Every time, every day,
she is my angel.

PRINCE AND PRINCESS

Kisses in the morning.
The Prince and Princess,
we are like a storm against the window,
as I hold you tight
and feel the softness of your body
and the warmth of your breath.
Your voice becomes soft and softer
and when you take control,
I lose control.
Now that I am your lover
and you are my lover –
since you came into my life –
the impossible is possible.

Luck is who I am, kissed by you
when I need to be kissed.
No one else is beautiful;
there is only you.
No matter where I go,
I end up by your side.
I never wonder what it is because
I know it's your love,
the chemistry between us
explains everything.
Prince is Princess and Princess is Prince.
You must be the one
sent from above.
No buts
No maybes.
I am in for life.

NO ONE BUT YOU

I see angels every day.
The stars in the sky
have seen God kissing the goddess,
the king kissing the princess.
My life is so pure.

I have seen continents collide,
the moon and sun falling down;
seen the mercy of God saving humanity
and cheated death more than once .

I have solved the impossible
and hoped for tomorrow,
but I have not seen anything
that nourishes my soul like you do.

You give me hope when I am in despair.
You teach me right from wrong.
You are everything I am not.
You make me better.
You give me life.
Babe, there's no one for me but you.

You inspire me when I am feeling down.
You give me joy when I am depressed.
You give me hope when I am in despair.
You kiss me and stop me from shaking.
Even when I see the shoes of God,
my heart does not beat, but my heart beats
when your shadow is all over me.

You make me better, not bitter.
You kiss me; you give me life.
Babe, there's no one for me but you.

WAPENZI

Just like lovers
loving each other
we love one another.
The only love I have seen, so pure.
Out of nowhere
you take me somewhere
and make me be everywhere
with your pure love.
Beauty and beautiful
created extra beautiful,
softer than velvet,
more beautiful than an angel,
I need you forever.
You are my beauty princess,
the one in my dreams.
You fly me to the moon.

You have conquered my heart.
Your love, I cannot live without.
Your charm and love, I can't resist.
I surrender! I am defeated, nowhere to hide.
You finally found my heart.

UNBREAKABLE

When life is meaningless,
it makes you careless
and all that you see
is sadness and loneliness.

I will be there for you.
Tight, I will hold you.
Be there when you need me.
The one you chose
to hold you and never let go
and I will hold you
and never let you go;
love you the way you want to be loved
'til the day we both grow old.

This love is untouchable.
It is unbreakable.

You and I together,
our love is stronger than ever
and it will be strong forever
so let's join the force together.
Don't face this life alone
without me by your side.

This is a house built on rocks
and with this strong bond
we have conquered imperfection
so forget the future and talk the talk,
walk the walk, live in the moment,
relax and enjoy the present.
Happy and content I feel
when you are in my arms.
Without you, nothing good baby
feels as good to me.

I will hold you
and never let go.
This love bond is untouchable.
This love is unbreakable.
It is unbreakable.

TREASURE

With loneliness deep in my heart,
blinded by regrets and imperfection,
all of a sudden you came into my life.

Let continents collide.
Let the moon and sun fall.
Let them say there's no chemistry between us.

The only thing I ever wanted,
the one thing I ever needed
was to find someone like you;
nobody else for me, but you.

Every girl I have kissed,
the women I have touched;
you're the goddess I desired.
No buts, no maybes – you are the one.
Let continents collide.
Let the amputees walk on their elbows.
Let them say true love does not exist.

The only thing I ever wanted,
the one thing I ever needed
was to find someone like you.
There's no one else for me, but you.

LOVE

Being with you in my life,
it's nice to finally see
that you're mine.
Lost in your love,
defeated by your beauty,

I've never felt like this before.
These feelings, I can't hide
when you are lying next to me.
No buts, no maybes;
you are an angel sent from above.

Let the amputees walk on their elbows,
let rivers and oceans dry,
let them mumble and fumble
that it ain't gonna work out,
but you and I deeply know the truth
and we don't need God to come from Heaven
to prove that there is a love bond between us.

I have never been so sure
like this before.
Finally one soul
understands the other.
You're my butter cup,
my honey bunny.

This is written in the stars,
two loves so in love.
One heart, one love, one destiny: you and I.

FINALLY

Finally, I found my treasure.
The perfect love I longed to find.
This is a dream come true;
the dream come true.

I feel so alive
and knew how blessed I was
the day I kissed you
and tested your love,
a love so sweet,
so sweet beyond sweetener.

I found someone I can count on,
someone who understands my soul.

Oh, the way you kiss,
the way you touch,
the chemistry between us.
Finally, you are lying in my arms.
We made it, finally.

THAT LAST NIGHT

It was an exciting night,
kind of a warm, cool breeze that night.
You and I had the best of it.
Hand in hand we walked that night.
School work we forgot and all of life's worries.
Your feelings of love, you gave me
and I kissed you, putting love in every kiss.
We lived out a love dream that night
and life felt so alive.
Do you still remember that last night?
A night so beautiful
we played games that lovers play
that last night: a night so beautiful.
One movie after the other we watched,
jamming rock and roll.
Love had found us,
the Universe had connected us;
two loves as one.
That night, you looked like
a princess in a fairy tale
and I was so proud to hold you in my arms.
Two loves lost in love,
a love sent from above.

DON'T GIVE UP

When life is not fair, as it sometimes is,
when the world is not innocent as it seems,
when those around you seem to be careless,
relax if you can, but don't give up.

When you try your best and don't succeed,
when the one you love thinks it's not love,
relax if you can, but do not give up.

Life is just life.
Every single day
is full of surprises.
Every star has life and struggles,
so always expect the unexpected.

Misunderstanding is part of human nature.
Desire for love and pleasure unites the human race.
We are all motivated by success and failure so,
relax if you can, but don't give up.

THE VISIONARY

I dream the dream:
things to come, I dream;
the future, I dream;
things to happen, I dream.
I am a dreamer.

Beyond my sight, I see.
Out the box, I see.
Good and evil, I see.

The impossible, I solve.
Problems, I handle.
In the jungle, I rumble.
The world, I conquer.
Problems ahead of me, I see.
Solutions, I get.

The world, I see,
the people, I see
and the future, I tell.

In crisis, the opportunities I see.
In despair, I hope the most.
I do not concentrate on
the problem, but the solution.

Some call me a dreamer,
some call me a psychic,
some call me a fake psychic,
but I call myself a visionary.

THE ONE

My eyes, you blew.
My mind, you blew.
My heart is swept away.

You are a dream.
In my dream,
I keep dreaming.
You have conquered me, body and soul.

MY LOVE

My love, you're mine
and I am yours.
You're my first thought in dawnie,
You're my last thought in duskie.

My love for you is so pure,
it's like the love of water,
the love of food
the love of sex.
You are irreplaceable.

My love, you're mine
and I am yours.
My love,
I love you.

ONE DESTINY

When we kiss, I see it.
When we dance, I see it.
We live every day
and talk every day in the language of love.

When I kiss, can you see it?
When I touch, can you feel it?
When I talk, can you sense it?
We live every day and survive in a spirit of love.

From Africa to America,
from Europe to Asia,
from coast to coast,
the wind of love blows.
We unite every day and think together in the language of love.

All around the world, it breaks the barriers,
something beautiful and amazing.
We breathe love, we feel love, we make love.

Stronger than hate:
one love,
one heart,
one destiny.

TOO BLIND TO SEE

I was too blind to see
how beautiful you are.
Five feet ten, black hair and Bambi eyes.
Welcoming are your lips and breasts.
Looking at you, my heart skips a beat.

I am sure men in Hollywood
staring at you are delighted
'cause you are a daisy and
you make them go crazy

when you shine like a
new penny,
you make boys go hazy.
When I look at your beauty,
my heart and my mind go lazy.
I was too blind to see
how beautiful you are.

GOODBYE

Laughter and joy we share,
ups and downs in our life are there,
with roses and candlelight, romance we make.

Kissing and hugging in public we do,
places of romance around the world we go.
Really, I and she love one another.

Faith and trust are the key
to loving one another deeply
and that's why we look so lovely.

I have to go because she is waiting,
wanting to talk about mating
and so I cannot keep her waiting.

Goodbye and be good.
I would have stayed
If I could.

BUNNY

Your kiss is all I want.
Your touch is all I want.
Nothing I want, but your smile.
Nothing I miss, but the softness of your tongue.

You are the best lover I've ever known,
the most beautiful thing I've ever seen.
It's you I want the most;
my heart is longing for you.
Don't leave me hanging.
So, shake it and roll it,
I will take it and control it
and to the climax I will take you.

The softness of your voice,
the smell of your skin,
the shape of your ass,
the taste of your lips.

The warmth when you take me there,
the touch when you touch me there,
the walk when we walk the walk,
the way you hold me when I am deeply there,
the way you look when you're in want.
I want you. I want all of you. So let's roll and flow.

HOW CAN LET GO

How can I let you go,
unless with me you go?
In different ways, I said I love you
and it's true; I love and want you.

You made me understand
that you're not the same – I understand.
When I wrote your name in my heart,
passion, love, in my heart deeply I felt;
that's the lust I feel for you.

I did wrong and that makes you doubt and mistrust,
but I want you to remember that no one is perfect.
You always taught me to be strong and stronger,
so be strong so our love can be stronger.

HE SAID:

I am like sugar
and sugar is sweet.
When you lick it
you get sticky.
You do not want to go away
and forever you want to lick it.

Sugar is love and lovable.
What I am saying is
I am not like sugar,
but I am sugar.
Sugar is not in me,
but it's me.

SHE SAID:

Because you are sugar
and I am so in love with sugar,
so sweet and sticky is sugar,
when I lick it, when I taste it,
oh, I cannot do without sugar.

I want you by my side all the time, sugar.
Because I belong to you, sugar.
You found my heart, sugar.
It's with you I belong, sugar.

But sometimes I doubt
if I've found your heart.
Sometimes I doubt
if you belong to me, sugar.

LOSING LOVE

I said perfect she was,
the one who knows what love is.
I laughed when mama said love is blind.
Now I know it was me who was blind.

How dare I not read the warning?
If I had, I wouldn't be miserable and weeping.
She is like a storm against the window,
following me around like a shadow.

She was everything I ever wanted.
Every day, she said it was me she loved,
now she is history
and that hurts me so deeply.

I miss seeing her around,
well dressed and walking like Miss World.
Nothing good feels good without her.
I keep calling her name, but there's no reply.

Without you, I am nothing.
I need you to keep living.
When you left, I thought it was a joke,
but now I know and I feel like a jerk.

I wish I could see your face once more,
but I know to you, this is another chime.

It has been a while since you left.
The house is too big and I hate it.
I decided not to stay last night
because I am tired of waiting
when our love is fading.

BAMBI

The way she smiles,
the way she walks.
She's got Bambi eyes.
Something about her sense of humour.
Something about the way she rocks me.
When I am with her, the world outside I cannot hear.
When I am making love to her, I like the way she whispers.
When I am tired, she's happy to chill.
Anything she asks me to do for her I will.

The one with nice legs;
the one with nice lips.
She's got the perfect boobs.
She's got the perfect butt –
no one else I desire.
Her love long time I felt.
Someone that hurt her I will pelt.

It's her I love,
the love of my life,
the one I'll call my wife.
She says I am in control,
but I know it's a lie
because to her I've surrendered.

THE WOMAN IN LOVE

For my love, I kept waiting.
The love we share, I kept seeing.
A few more minutes, I kept waiting;
I waited and waited and kept waiting.

The walls slept and woke up
and I was still waiting,
then they asked me,
"Beautiful, what are you waiting for?"
I replied, "The one I love I am waiting."
When he finally came,
I kissed him and held him tightly.
Then, I took him to my bed.
I kissed him and put him in my private room
where it was soft, steamy and warm.
When all that was over, to him I said,
"Please think outside the box
and do not be like my ex."

MY ONLY

I found the one.
The love of my love,
my lover, my bride,
my hope, my treasure.

You are the only one
I think of because
you make me better, not bitter.
My love, I will always love you.

A MAN IN LOVE

What I want most is your love.
What I want most is your care.
The scent of your skin takes me there.

To hear your voice is fortune,
your hug is a blessing,
so relax and let me hold you
'cause I love you more than ever.

LOVE ME AGAIN

Love me and love me again
because your love runs through my veins.
Charming and beauty, God gave you.

No wonder men love you.
Let's go far away, you and I
where your father cannot find us.

COURAGE

So far, so good.
The storm blew, but I stood,
holding on the best I could.
The imperfection I conquered;
in my eyes it seemed impossible,
but a man in the mirror said I was capable
and now I can see the walk is walkable.
Hope was the key.
Determination led the way.

Courage was the horizon.
Patience made me stay.
Hope is the best thing;
without it I could do nothing.
Even when it was troubling,
because of hope I was smiling.
A person without hope is like a ship without a compass.
I am glad hope found me;
otherwise, I would not be here.

SPRING

A warm, cool breeze is blowing.
On the river, the ducks are swimming,
the sun is shining and people are smiling,
kids are outside happy and playing,
the sky is clear and evergreen is greener,
the air is fresh and clean and the wind keeps blowing.

No more big jackets.
No more big boots.
On our necks, no more scarves.
On our hands, no more gloves.
The air is fresh and clean, the wind keeps blowing.

No time to hide in the house like a bear,
so let's get out to party and drink beer
at the beach chicks relaxing in shirts and bikinis
waiting for sunset to party and drink martinis.
The air is fresh and clean, the wind keeps blowing.

It's time to rock and roll.
Our hearts are full of joy,
so boys and girls join the party;
it's time to celebrate and enjoy.
Jamming and singing is the best we can do
so come on feel good and let's do the do.
The air is fresh and clean, the wind keeps blowing.

TROUBLE

My name is trouble,
so I ain't afraid of trouble.
Like a lion in the jungle,
life and love, I jingle.

Fear and doubts, I conquer.
Problems and puzzles, I solve.
Wars, I fight one battle at a time
'til the enemy surrenders.
All the ranks, I get.

When I organize, they fumble.
When I hit, they stumble.
When I am calm, they jumble.
When I am quiet, they mumble.

I am liberated
and enlightened.
I am good hearted,
suave and proud.

My name is trouble
and I ain't afraid of trouble.
So do not trouble the trouble
before trouble troubles with you.
My name is trouble.

THE ARCHIEVER

In darkness living,
my eyes are icing,
the pain in my heart is growing.

Thinking of making it
and if I do make it,
I will be proud and be proud
striving to be someone,
but there are many challenges
and that makes me feel inadequate.
I want to keep the candle burning,
but so hard the wind is blowing.
God, please hear my prayers:
I will join the game and learn all the rules,
do what it takes 'til I win the prize.
I will hope and be determined, optimistic and feel good enough.
The Achiever will be my name.

THE STRUGGLER

Mama bore me struggling
and just like struggle, I have been struggling ever since.
Even now, as I am speaking I am struggling.
I know it's not easy living your life struggling,
but I cannot stop the struggle
because I know I will break through the struggle.
I am suffering and life is hardening,
but I keep hoping and believing
while looking for the way through,
determined to break through.

In myself believing
is what keeps me going,
otherwise, I would not be standing
with my heart full of hope.

I cannot complain because
I know I am not the only one
and it's true that life
is a struggle and we all struggle for the same thing.